Lettering for Planners

Published by Mango Publishing Group, a division of Mango Media Inc.

Cover and Layout Design: Elina Diaz

For permission requests, please contact the publisher at:

Mango Publishing Group
2850 Douglas Road, 2nd Floor
Coral Gables, FL 33134 USA
info@mango.bz

For special orders, quantity sales, course adoptions and corporate sales, please email the publisher at sales@mango.bz. For trade and wholesale sales, please contact Ingram Publisher Services at customer.service@ingramcontent.com or +1.800.509.4887.

Lettering for Planners: A Step-By-Step Guide to Hand Lettering and Modern Calligraphy for Bullet Journals and Beyond

Library of Congress Cataloging

ISBN: (print) 978-1-63353-925-9 (ebook) 978-1-63353-926-6
Library of Congress Control Number: 2018962596
BISAC category code: ART003000 ART / Techniques / Calligraphy

Printed in the United States of America

Lettering for Planners

A Step-By-Step Guide to Hand Lettering and Modern Calligraphy for Bullet Journals and Beyond

Jordan Truster & Jillian Reece

Loveleigh Loops

mango

CORAL GABLES

Contents

Introduction

So, you love your to-do lists. But you're not the type of person to just grab the nearest scrap of paper and pen to scribble down tasks.

No. You're the kind of person who appreciates organization and adds your creativity into something as everyday as a planner. (We *totally* get it, even if your friends and family don't!)

Your tasks, schedule, and notes deserve more than a scribble, and maybe you've tried your hand at decorative lettering but you're just not sure where to start. You're afraid to ruin the pages of your journal and so you've stayed away from getting too fancy. Sound like you? We've got you covered!

We'll walk you through the steps of how to hand letter a basic script alphabet with confidence, focusing on the basics to build up a strong foundation for the details. Then, we'll move into more letter styles and embellishments so that you can create truly unique lettering. We have tons of examples of "dos and don'ts" throughout the book to help you learn.

There are lots of benefits to learning hand lettering, particularly in the context of journaling.

- ◆ It's a relaxing and therapeutic hands-on activity, especially in our digital age
- ◆ You can do it anywhere, unlike some other crafts and hobbies

- It's completely customizable (no need to search for a stencil or buy a bunch of fonts!)

The best part? It doesn't take a long time to learn, and you don't need to buy fancy calligraphy supplies. You can get started today with supplies you already have.

From Jillian

You know those small moments in life that you never expected and will never forget?

I was in eighth grade. I always decorated my homework pages with colorful lettering and borders and doodles. If anyone could make the words "Chapter 12: Homework" look less boring, it was me!

Anyway... One spring afternoon after turning in my homework, my history teacher, Mr. B, told me to see him after class. Mind you, I was the straight-A student who *never* got in trouble, so I was terrified.

After forty-five nerve-wracking minutes of class, I walked up to his desk. He held up my homework and said: "All this art and doodles? When you get to high school and college, your teachers are going to tell you to stop. *Don't ever stop.*"

I'll never forget how unexpected and supportive his comment was.

While I went on to study business and data analytics in college, I never stopped lettering. I didn't need to be an artist or have a lettering business in order to be creative; it was just a part of my everyday life. It was a way to make my class papers and grocery lists a little more fun. And since

you've picked up this book, then you're probably wired the same way.

We wrote this book to guide you through creative script lettering so that you can stop wasting time feeling stuck and start spending more time creating.

As our lives become more and more digital, I want to remind you: Don't stop using your hands to make a creative mess. Don't put down those pens and markers. Don't stop adding that personalized touch. Don't ever stop creating. My sincere hope is that this book will help you do just that.

Xoxo,
Jillian

From Jordan

Growing up, math was my favorite subject. I competed in math and science competitions in grade school, my favorite high school classes were geometry and physics, and I studied engineering in college.

So, why do I love calligraphy and lettering?

Calligraphy is a science as much as it is an art. My affinity for math has always been accompanied by a passion for art, design, and creativity—especially since I grew up with an incredibly artistic twin sister. We spent much of our childhood experimenting and creating together. We had every craft-related *Klutz* book...friendship bracelets, nail art, origami, handmade cards, and of course, lettering.

When I got back into learning lettering as an adult, I wanted to know exactly how to make each shape, the correct

angles to draw the lines, and how to make the letters look beautiful. I needed rules to follow, I needed to understand the logic behind this art.

And this is exactly how I will help you!

If you use a planner or bullet journal, I'm guessing you like when things are organized and easy to follow. Calligraphy might seem daunting, but this book is going to guide you through it, starting with the basics and then building on that foundation in easy-to-follow steps. You'll learn how to write specific words in a variety of styles to apply immediately and directly to your journal.

So, whether you are creative and artistic, mathematical and logical, or a combination of both, I believe you can do this!

Your lettering friend,
Jordan

From Jillian & Jordan

Keeping track of our daily lives has always been important to us, from grade school throughout adulthood. When we started to incorporate hand lettering into this ritual, we became obsessed.

We've studied calligraphy for several years and have taught the skill to hundreds of students in-person and thousands online. We're taking our in-depth knowledge of this craft and consolidating it into a format that directly relates to planners and journals, giving you exactly what you need to get started with lettering in a non-overwhelming, easy-to-implement way.

Over the years, we've developed our own unique styles, which surprises a lot of people considering that we're twins. So we made it our mission to crack the code on lettering styles. There are *so* many ways to express an idea or change the tone simply by switching up letter variations or other basic elements. Here's an example of Jillian's style (top) versus Jordan's:

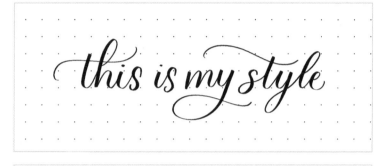

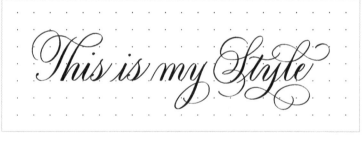

We'll be sharing a variety of alphabets with you in this book so that you can understand and try new styles as well. We'll show you a basic alphabet, then demonstrate how new styles and variations can be created with lots of examples. In fact, you'll get six lowercase alphabets, twelve capital alphabets, and over 350 word examples throughout the book.

If you are new to lettering, you're probably not looking to buy all the fanciest calligraphy supplies or take an intensive year-long study of this craft. Instead, you're looking for

the top tips that you can quickly apply to beautify your everyday life. That's what we're here for.

How to Use This Book

One of our strongest beliefs is that you must learn the basics before you can break the rules and find your own style. So, that's how we organized this book. We encourage you to work through this book chronologically rather than skipping around so that you can build on a strong foundation.

There's room to apply what you're learning right away, or you can grab your favorite journal and keep it close by to practice. We've also added our top tips at the end of each chapter to help summarize and reinforce what you're learning along the way.

Our most important piece of advice when using this book is to *keep going*. Even with our help, you're not going to get a perfectly hand-lettered alphabet on your very first try (*we sure didn't!*), but we can promise you that with just a little bit of practice each day, you'll soon see results that you can be proud of. Plus, we're cheering for you.

Happy lettering!

<div align="right">
Jillian & Jordan

Founders of Loveleigh Loops
</div>

Chapter 1

How Do I Incorporate Lettering Into My Planner?

One of our favorite things about lettering is that you can use it anywhere you'd like! Since there's a limited amount of space on every page, though, it would be hard to fit in *every* word with decorative lettering. So here we have suggested some places that work best:

Page Titles (e.g. "Future Log")

The main title of a page is one of the best places to add lettering. Why? Because titles are usually short, important, and larger than the rest of the words on the page. Titles are meant to stand out, and lettering is a great way to make them pop. Plus, since most titles are only a few words, they're less overwhelming to tackle than an entire paragraph.

Section Headers (e.g. "Mood Tracker")

Sections within a page or spread, such as a habit tracker, can get lost if there are a lot of notes or doodles around it. Lettering your headers is a great way to define each section and convey what it's all about. Making the words "Water Tracker" or "Exercise Log" look fancier *may* even make you more excited to reach your goals!

Lists (e.g. "Books to Read," "Healthy Meal Ideas")

Similar to section headers, list titles are usually very specific, which makes them a great place to add lettering. The words can be decorated to match the theme of the page, and spending time lettering them makes them harder to forget.

Full-Page Quotes or Dividers (e.g. "Summer!" or a full quote)

An entire page that's dedicated to a quote or lyric is like a giant blank canvas for your lettering! This works especially

well with a longer quote because you can pick the most important words to letter, and write the other words in a plain style. A full-page divider, such as the start of a new month or season, is also a prime place to set the tone for that month's theme using hand-lettered details.

Monthly and Daily Spreads

The names of the months and days of the week have always been some of our favorite words to letter. There's so much you can do, such as flourishing the "y" at the end of each "–day". Plus, they're familiar words that are comfortable to write, and since they appear frequently, you can try out different styles each month.

Special Occasions and Holidays
(e.g. "Sister's Birthday", "Merry Christmas")

Celebrate special moments by beautifying the letters in your journal or planner. You can use colors and style to make them more special, such as writing "Our Anniversary" in a romantic script, or using black and orange for some edgy Halloween letters.

The Cover

The cover is the perfect place to add a personalized touch, like your name or a meaningful quote. Depending on the material of your planner, you may need to use something other than a regular pen. Permanent markers, paint, and embossing powder are great for non-paper covers, but we recommend practicing with a pencil before writing directly on it with something permanent.

Tips

For each of these opportunities, we have some advice. The most important is to take your time. Lettering should be enjoyable, and the more relaxed and focused you are, the more pleased you'll be with the results.

We also recommend sketching with pencil before inking over it, especially when you're first getting started. We've made plenty of spelling mistakes that are hard to fix when they're inked. Plus, sketching will help you measure the spacing and ensure that you don't run out of room.

Lastly, think about the size of your words in relation to their importance. You may consider page titles to be very important, whereas section headers are of secondary importance. More significant words can stand out if you make them larger. For example, if you use a dot grid journal, you could make page titles twice as tall as section headers by doubling the number of grid spaces used for the letter height.

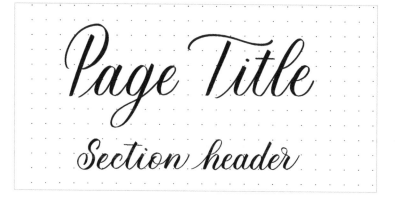

Overall, remember that this is your journal. There are no "rules" about where you can or can't use lettering, and it's ultimately your choice how to incorporate this skill into your daily life.

Takeaways

- Go big! Larger text is easier to letter and decorate than small text.

- Keep it simple starting out and focus on short phrases.

- Pick important words that you want to emphasize, rather than decorating "boring" words (unless, of course, you want to make something boring more exciting).

- Sketch your lettering in pencil before inking over it so you're not nervous about spacing issues or spelling errors.

Chapter 2

Lettering Overview

What Is Hand Lettering?

What is the difference between cursive, lettering, and calligraphy? What types of pens are used for which? If you've been pondering these questions, you're not alone! There's a lot to learn, so let's start with the basics.

Lettering encompasses any letter, word or phrase that is drawn by hand. It focuses on the construction of the letter forms through drawing.

Sounds pretty simple, right? As long as you're using your hand to create the letters, you're doing hand lettering. However, using a keyboard, stencil, stamp, or other pre-made letters is not hand lettering.

Handwriting is what is used for every writing, like when you're quickly jotting down a note. *Cursive* is a type of writing that you may have learned in school. The purpose of cursive is to write quickly without lifting the pen off of the page, resulting in letters that are connected together. Handwriting and cursive are not considered hand lettering because the letters are written, not drawn.

What Is Calligraphy?

Calligraphy is considered to be part of the lettering category because it involves drawing letters using specific strokes. The characteristic look of calligraphy is achieved by a contrast between hairlines and shades (also known as thin and thick lines) within the letters.

Traditional calligraphy scripts follow precise rules, angles, and structures that have been around for decades. Some examples include Copperplate and Spencerian. Modern calligraphy, on the other hand, allows you to bend the rules. There are certainly some guidelines to keep in mind (we'll cover them throughout the book), but you have the freedom to make the style your own.

Despite the fact that lettering requires drawing, you don't need to be an artist to be successful. In fact, as long as you can create some basic shapes, you can hand letter! We'll cover some of these basic shapes later on, but for now, here's a visual comparison of different types of writing and lettering.

Handwriting

Cursive

Calligraphy

Modern calligraphy

Tools

The contrast between thick and thin lines is what makes calligraphy look like calligraphy. It can be done with a variety of tools, and the contrast is created differently depending on the tool used.

Brush calligraphy uses a flexible marker-like pen called a brush pen, and dip pen calligraphy involves dipping a steel nib into ink. For faux calligraphy, you can use *any* pen that writes with a consistent weight, which is what we're focusing on in this book.

Faux calligraphy involves drawing letters to make them look like calligraphy without the need for special calligraphy tools. It's a great way to use the pens that you already have, such as highlighters, gel pens, fine liners, ballpoint pens, markers, or colored pencils.

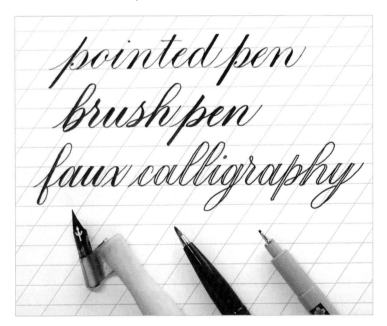

Now, we will take a look at these three popular methods of creating calligraphy and compare the pros, cons, and other notes of each.

	PROS	CONS	OTHER NOTES
Dip Pen (broad edge or pointed pen)	◇ Writes on light and dark colored paper and other surfaces ◇ Custom ink colors ◇ Professional and elegant	◇ Best for small scale lettering ◇ Ink smudges easily and needs time to dry completely	◇ Since you have the ability to mix custom ink colors, the possibilities are limitless ◇ Thick and thin lines are created by varying the pressure of the pen (for pointed pen) or changing the direction (for broad edge)
Brush Lettering	◇ Range of pen tip thicknesses for different applications ◇ Great color variety ◇ No mess, easy clean-up	◇ Will not work on most surfaces beyond paper ◇ High quality brush pens can get pricey	◇ Works well on paper goods including: envelopes, place cards, framed paper, and journals ◇ Thick and thin lines are created by varying the pressure of the brush pen
Faux Calligraphy	◇ Can be practiced with any tool; no need to buy specialized pens ◇ Able to write on any surface ◇ Great for large scale lettering	◇ Time-consuming ◇ Creating consistent stroke widths requires more attention to detail	◇ The artist determines the width of the strokes (unlike brush and pointed pen, where the tool does), so you can scale the words to fit any size ◇ Modern tools are used for faux calligraphy

Lettering Anatomy

There are lots of terms that can be used to describe the anatomy of letters, but we've chosen four of the most important ones to know in the context of lettering in your planner.

- **Baseline:** The line, imaginary or drawn, that the letters sit on
- **X-height:** The distance from the baseline to the top of the lowercase "x" (and other short letters, like "n")
- **Ascender:** Parts of a letter that ascend above the top of the x-height, like the loop of an "l"
- **Descender:** Parts of a letter that descend below the baseline, like the loop of a "g"

Takeaways

- Calligraphy is characterized by thick and thin strokes, which are created either by adding pressure on a flexible pen, or by going back over the downstrokes with a monoline pen to manually thicken them.

- Faux calligraphy is a great way to start lettering because you can do it with supplies you already have.

- Even though faux calligraphy involves "drawing" the letters, you don't need to be artistic to be successful.

Chapter 3

What Are the Characteristics of Calligraphy?

Let's start with some examples. The word "monoline," below, is written in a single weight, also (predictably) known as monoline. The word "calligraphy" has thick lines and thin lines.

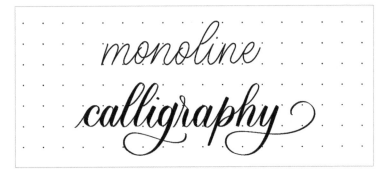

You can achieve the calligraphy look with a monoline pen simply by adding the thick lines after writing out the word in a monoline script first. We'll show you exactly where to add the shades soon, but first let's go over more characteristics of calligraphy.

Straight Baseline

If you've ever tried writing on a piece of paper with no lines, you've probably noticed that your letters start getting bigger or smaller, and the lines go up or downhill. How do we know this? Because the same thing has totally happened to us!

Consistency is a key component of creating beautiful letters. Using paper that has reference points, like horizontal lines or a dot grid, can help you keep the letters straight and consistent in height. You could also use a pencil and ruler to create a baseline if your pages are blank.

Writing on a straight baseline will help with the overall neatness of your lettering.

Slant

Another characteristic of calligraphy is the overall slant of the letters. Instead of standing upright, calligraphic lettering typically "leans over" at an angle, similar to the *Italics* setting for fonts. Traditional calligraphy scripts have exact angles that the letters must follow, but in modern calligraphy, it's up to you how upright or slanted you letter.

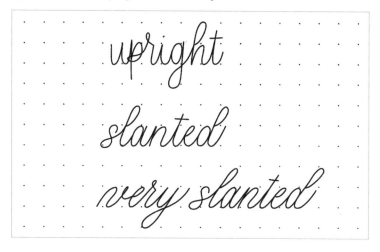

Shading

To show how shade placement drastically changes the look of a word, let's take the word "calligraphy" and shade the skeleton in three different ways.

Here's the skeleton:

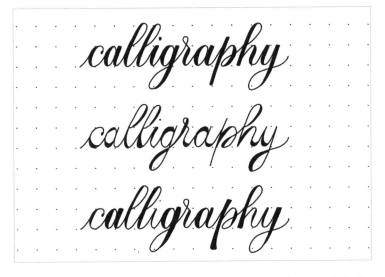

Given that the three variations of the word *calligraphy* below were created based on the same skeleton but with different shading, which one looks best to you?

To us, the first option is the most pleasing to the eye. Why? There are two reasons.

1. Shade Placement

The thick shades should all be placed on the down strokes. Wherever the pen travels down toward the baseline, the stroke has been thickened. We'll be using arrows throughout the book to help show you where the down

strokes are. The second variation looks strange because upstrokes and horizontal strokes were thickened.

In the third variation, only the down strokes have been thickened, which is the correct placement, so why does it look odd?

2. Shade Consistency

The thick lines should be consistent in width. This takes practice, but it's best to avoid shades that are much wider than others.

We'll dive further into shade placement and consistency in the next section, but for now just keep in mind that contrast between thick and thin lines is an important characteristic of calligraphy.

Takeaways

- Calligraphy is characterized by a contrast between thick and thin strokes.
- The downstrokes are always thickened, and the upstrokes are left thin.
- All thick strokes (shades) should be the same width as each other.

Chapter 4

Downstroke Creation

To create the look of calligraphy using a monoline pen, start by writing the letter normally with a thin line. We have alphabet examples later in the book, but for now you can use your regular print or cursive writing to get started. These thin letters become the "skeletons" or main foundation unto which the thick downstrokes will be added.

As you draw the skeletons, pay attention to wherever the pen is moving in a downward motion (coming down the page toward you). It may help to draw small arrows.

Once you've determined where the downstrokes are, you'll make them thicker by drawing a second line next to it.

Here are the basic steps:

1. Create the monoline skeleton of the letter and find the downstrokes.

2. On the downstrokes, draw a parallel line next to the one you already have.

 ◊ Try to maintain a consistent distance away from the skeleton throughout the letter.

3. Carefully fill in the gap (or you can leave it open for a different look!).

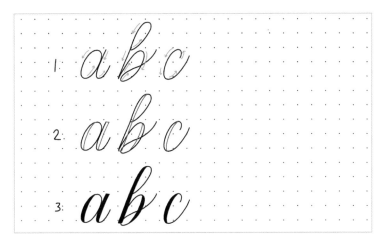

Adding a parallel line next to a straight line is fairly straightforward (pun intended). But how do you deal with shading a curve? Just remember: always shade on the *inside*. The only time it might be confusing is if you have a shape known as a compound curve, which doesn't have a clear "inside." We'll come back to that, but first, here are some examples of shading inside the curve:

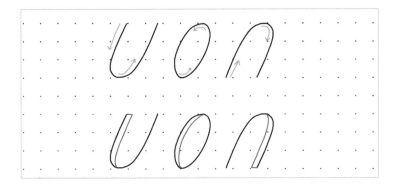

The purple line is added *inside* of the curve so that the overall width of the shape does not change. Notice how the shade tapers as it reaches the curve, and stops where the black curve reaches its highest or lowest points.

Let's compare this example with what to avoid. In the picture below, the skeletons are the same as above, but the shading (purple line) has been added to the outside of the curve:

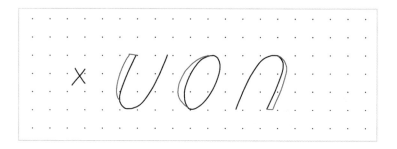

This creates much wider letters and changes the overall shape, which we advise against.

A shape known as a compound curve, which appears at the end of the lowercase "h," doesn't have an obvious "inside" of the curve. This is because the curve changes direction twice.

There are three options to add shading to this shape that achieve the same result, which are illustrated below.

1. Add shading to both sides of the center line.
2. Right half is wider than left; the shade line is added to the right of the downstroke.
3. Left half is wider than right; the shade line is added to the left of the downstroke.

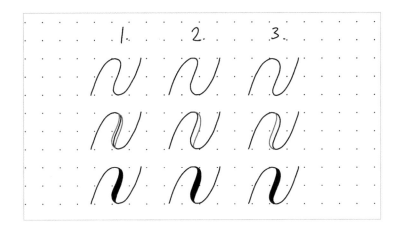

Whatever method you choose should produce the same result. This shape appears in the following lowercase modern calligraphy letters: h, m, n, v and x.

A Special Note on Brush Pens for Downstroke Creation

While faux calligraphy involves thickening the skeleton by drawing shade lines, the technique of creating downstrokes differs if you decide to use a brush pen. A brush pen has a flexible tip, so when you press harder on it, the line gets thicker. In the context of creating thick and thin lines with a brush pen, the placement rules are the same (i.e. thick shades are added to the downstrokes).

Thick lines with a brush pen are made by pressing down harder on the downstrokes and lightening the pressure on the horizontal and upstrokes. This means that you can skip the step of filling in the gaps because they're filled in as you go.

You can use brush pens to work through the rest of this book if you're comfortable using them, or you can simply use a monoline pen and apply the faux calligraphy method.

How to Achieve a More Realistic Calligraphy Look

Remember the example we showed in the previous chapter of three options for the word "calligraphy," with three different shading options? Now, we're going to dive into even more specifics on why the first option looks the best, and how to avoid the two incorrect examples.

The key message is that consistent shading will create the best results. Inconsistent shading looks less like calligraphy.

Here are four specific mistakes to avoid:

1. **Over-shading:** Don't extend the shade beyond where the curve hits the highest or lowest point of the curve.

2. **Shading on the outside of the curve:** This changes the overall shape of the curve, making it too wide.

3. **Shading horizonal:** Avoid shading horizontal sections of the curves.

4. **Inconsistent shade widths:** Try to make the thickened line the same thickness for your entire word.

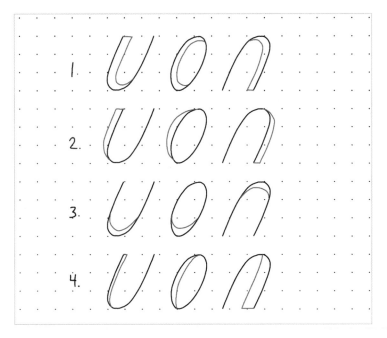

An exception to the second mistake to avoid (shading on the outside): If you accidentally draw a letter too narrow compared to the others, shading on the outside of the curve will help the letter look wider and more consistent.

Just a reminder, it's perfectly okay to start with a pencil sketch before inking over your letters.

Takeaways

- Draw the skeleton of your letter first.

- Pay attention to the spots where the pen travels down toward the baseline (the line where the letters rest); the downstrokes are where they're thickened.

- The thickening of curves should be added to the inside of the curve and should taper back toward the skeleton at the highest and lowest points of the curve.

- Consistent shading of the downstrokes will make your faux calligraphy look more realistic.

Chapter 5

Basic Strokes

Using your normal print or cursive letters is an excellent way to start practicing the faux calligraphy technique of thickening the downstrokes. Once you're comfortable with the idea of adding thickness, you can start learning the basic faux calligraphy alphabet, which may look different from your natural script. There are seven basic shapes that appear throughout the calligraphy alphabet.

The shapes are:

1. Entrance stroke
2. Underturn
3. Overturn
4. Compound curve
5. Oval
6. Ascending loop
7. Descending loop

Here are the skeletons:

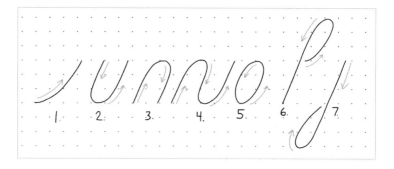

Before examining the next example, try adding the shades on the downstroke on your own. Remember, the shades go only on the downstrokes.

Now, here's what the basic strokes look like with thick shades added:

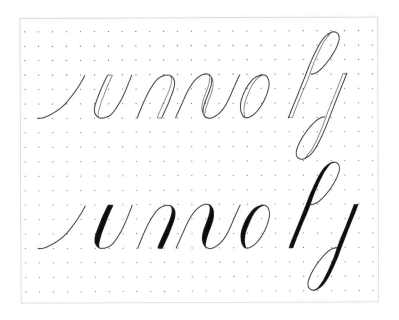

These seven strokes will appear throughout the faux calligraphy alphabet examples and will give your lettering a more realistic calligraphy look. We'll show you where they show up in each letter in the next section.

Takeaways

- There are seven basic shapes that appear throughout the alphabet.
- Using these basic shapes will help your calligraphy look more realistic.

Chapter 6

Creating Lowercase Script Letters

Let's create the lowercase alphabet by following these three steps.

Step 1

Draw your letters with thin lines, making sure that they aren't too narrow or tight. You'll need space to add in the downstrokes later. Pay close attention to where the downstrokes are drawn.

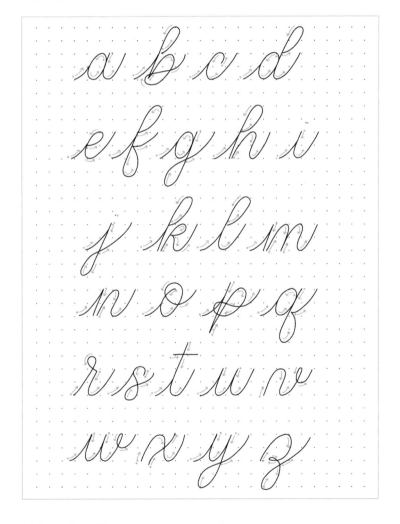

Step 2

On the downstrokes, add a second line parallel to the lines you've already drawn (shown in purple below). Try to keep the amount of space between the two lines as even and consistent as possible for the majority of the downstroke. As you reach the end of a curve, taper the line toward the curve.

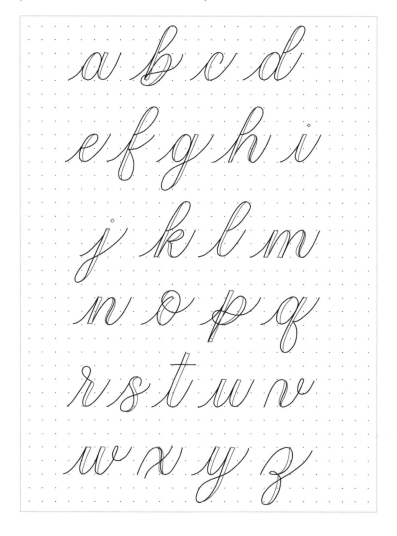

Step 3

This step is optional. Carefully fill in the gaps that you created so that the downstroke looks like one thick, solid line.

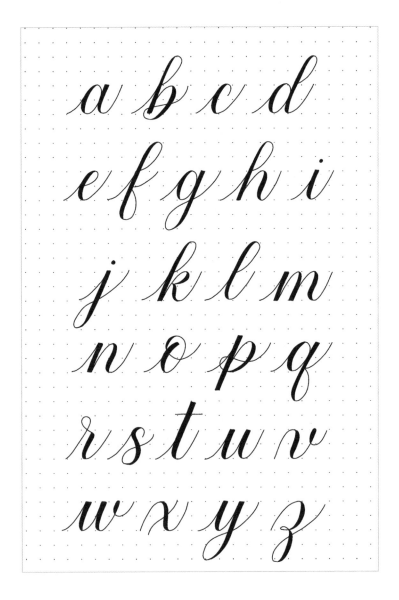

How Thick Should the Downstrokes Be?

While there's no "rule" for the thickness of the downstrokes, in general, we find that we most commonly create a thick stroke that is three to five times wider than the thin stroke.

Exception: If you have very limited space and need to write small, or if you're using a very thick pen, you may only need to thicken the skeleton with a single extra stroke (i.e. double the thin line).

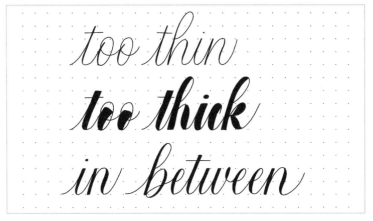

If the downstroke is too thin, there won't be enough contrast between the thick strokes and thin strokes to produce a noticeable calligraphy effect. If you make them too thick, it will take much longer to fill in the gaps and your letters could look too "chunky" or hard to read. But at the end of the day, it's up to your personal preference to determine how thick your downstrokes should be. Just remember to keep them consistent throughout the entire word.

You can write your letters in your own script style, or you can think about the seven basic strokes from earlier in this chapter that recur throughout the alphabet. Here they are again, color-coded within the alphabet:

Oval (Blue) and Compound Curve (Pink)

Underturn (Pink) and Overturn (Blue)

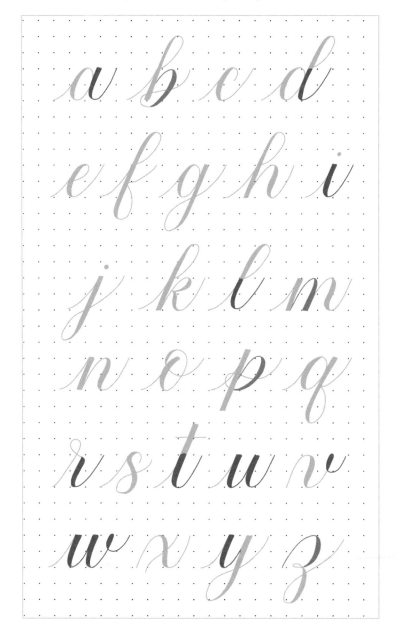

Ascending Loop (Pink) and Descending Loop (Blue)

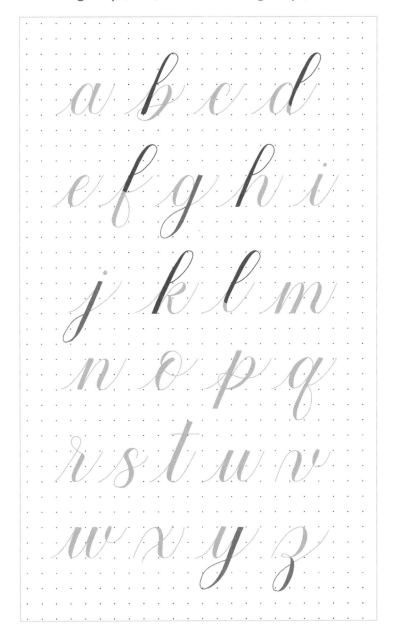

Takeaways

- When doing faux calligraphy, start by creating the skeleton of the letter in thin, monoline strokes, leaving enough room for thickness to be added.

- Find the downstrokes and add thickness by drawing a line parallel to the skeleton, tapering toward the curves.

- Consider using the seven basic strokes to create consistent, realistic-looking calligraphy alphabets.

Chapter 7

Connecting
Lowercase Letters

Putting letters together to create words in calligraphy is similar to cursive in that the end of the first letter connects to the start of the second. The big difference, however, is that in calligraphy the pen should lift off the page as you create each stroke.

Here's the easiest way to think about letter connections: the final upstroke of the first letter becomes the entrance stroke of the next. In the examples below, the purple exit and entrance strokes are "fused" together to create a single stroke that connects the letters.

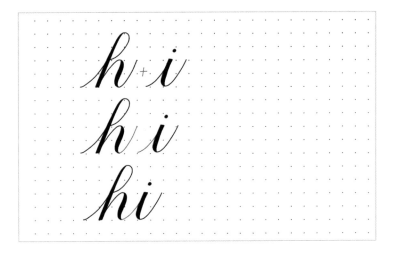

If these two strokes are at different heights, such as the "w" and "e" in "week," simply choose the shortest path as illustrated below.

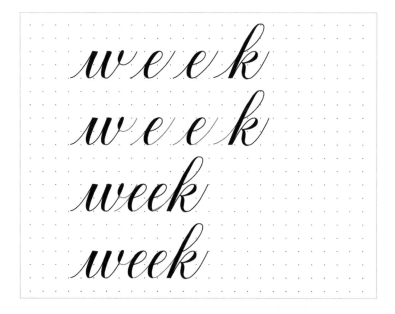

You have two options for creating words in regard to downstroke thickening. The first is to write the entire word in thin strokes, then add all of the thick strokes at the end. The second option: complete each letter one at a time, adding the downstroke shades as you go. Both methods are valid, and you'll figure out which feels more comfortable to you as you practice. Either way, just be sure to leave enough space within and between the letters to thicken the downstrokes. Go slowly and lift your pen after each shape (remember, this isn't cursive!).

Consider the spacing within your word. There should be approximately the same amount of visual white space between each letter. While you can play with the spacing and make it loose or tight, the important part is maintaining consistency.

There are a handful of letter combinations that are trickier than others because the start and end points don't match up

intuitively. Based on questions from our students, we've put together some examples of the trickiest combinations below:

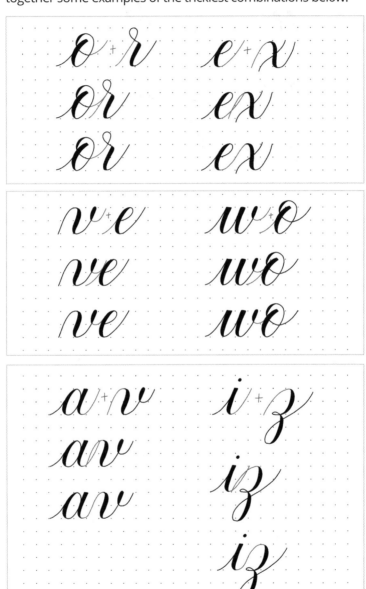

There are a few "don'ts" to avoid when it comes to letter connections, as illustrated below:

1. Don't make a choppy thin line between the letters. The thin connecting stroke should be smooth

2. Don't connect the letters too close to the baseline as the letters tend to look cramped and this makes them harder to read.

3. Don't leave an inconsistent amount of space between the letters.

4. DO connect the letters with a smooth thin stroke that connects high enough on the next letter with consistent spacing.

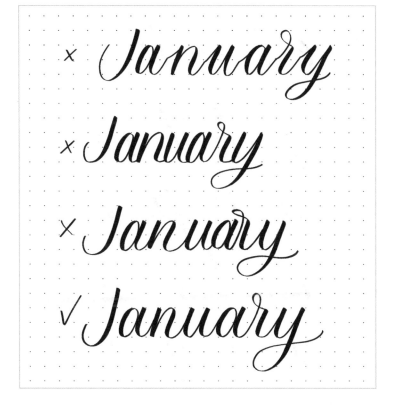

If you're stuck trying to figure out how to write a combination of letters, grab your pencil and write the letters separately. Then, look at how the first one ends and the second begins and determine where the overlap is. These strokes are what you will "fuse" together to create a single transition. The alphabet below highlights the entry and exit strokes in purple.

There are dozens of word examples in the back of the book as well that you will show plenty of common letter combinations.

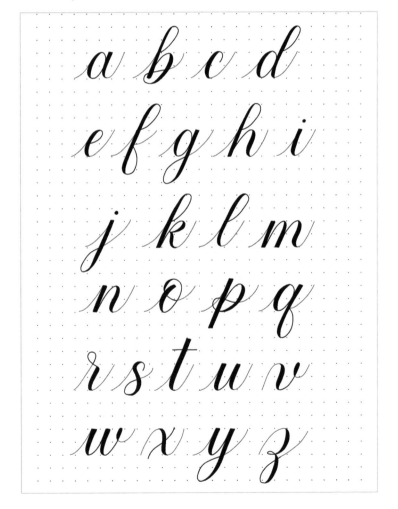

Takeaways

- In script lettering, the letters are connected together using thin strokes.
- Maintain consistent spacing between your letters.

Chapter 8

Block Capital Letters

Block letters are simple, printed capitals that are great to use with your script lettering. You can use block capitals in areas that need clear, easy-to-read text. They allow the script letters to stand out and are great for mixing and matching. We'll talk more about mixing and matching capital and lowercase styles in a later section.

The basic components of block capitals are:

1. Straight vertical and horizontal lines (purple)

2. Diagonal lines (blue)

3. Curves (yellow)

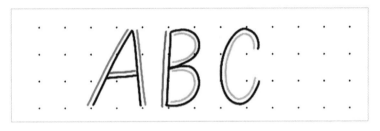

Here is an example of a basic block alphabet. The first version stands two units tall and works well for areas where larger text is needed, and the second version is the same alphabet scaled down to one unit tall.

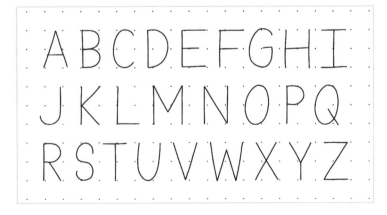

ABCDEFGHI
JKLMNOPQ
RSTUVWXYZ

To add diversity, you can easily change the look of block capitals by adding thickness to them. Thicken all of the lines for a bold look (use a thicker pen to achieve this look more quickly) or thicken just the stems of the letters. Here's what those two examples look like:

ABCDEFGHI
JKLMNOPQ
RSTUVWXYZ

ABCDEFGHI
JKLMNOPQ
RSTUVWXYZ

ABCDEFGHI
JKLMNOPQ
RSTUVWXYZ

Another way to write the block capitals is by drawing the outlines of the letters. To practice writing the outlines, first draw the basic alphabet, then draw lines that follow the outside of each letter and outline the inner areas/loops. You can write the skeleton in pencil, trace in pen, and erase the pencil to leave behind just the outlines. As you practice, you may eventually be able to skip the skeleton step and go straight to the outline. Try to keep an even amount of space within the outline at every point on the letter.

ABCDEFGHI
JKLMNOPQ
RSTUVWXYZ

ABCDEFGHI
JKLMNOPQ
RSTUVWXYZ

Tip: when you outline a sharp corner or angle, you can cut the triangle across the top to maintain the letter proportions.

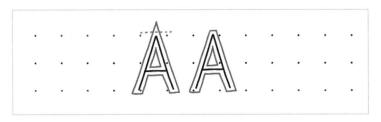

Takeaways

- Block capital letters contrast the script style and are used in areas where clear, easy-to-read text is needed, or for creating layouts mixed with script letters.

- Think of each capital block letter as a combination of straight lines (vertical, horizonal, diagonal) and curves.

- Get creative and create shaded or outlined caps for a totally different look.

Chapter 9

Script Capital Letters

Script capitals are paired with the lowercase script alphabet and are used at the beginning of sentences and words. Capitals are two to three times taller than the x-height.

If you need to write a word entirely in capitals, we suggest using block letters instead of script. Stringing together script capitals is difficult to read:

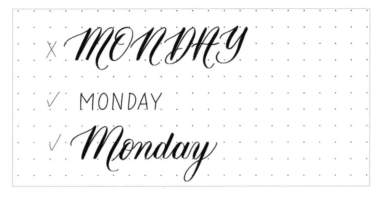

There are many ways to write the script capital letters and you can make them your own, as long as you remember to follow the basic rules of calligraphy:

- There are thick and thin lines.
- Thick lines are placed on downstrokes.
- Thick lines in script capitals should have the same thickness as lowercase letters.

There's no "right" or "wrong" way to write script capital letters as long as you keep these principles in mind.

The steps to creating capitals are similar to the method of forming lowercase letters.

1. First, create the "skeleton" of the capital letter in a single width (monoline), making sure to leave enough room for the thickened downstrokes.

2. Then, add the shades by drawing a line parallel to each downstroke in the letter, connecting the top and bottom to the skeleton. Keep the second line along the inside of the curves. The thick strokes should be as wide as the lowercase letters' thick strokes.

3. Fill in the shades.

These three steps are shown for the following alphabet examples: basic script caps and flowy script caps.

Basic Script Capitals

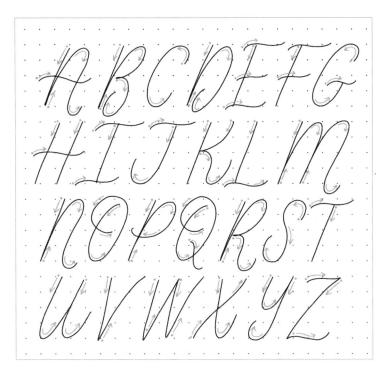

ABCDEFG
HIJKLM
NOPQRST
UVWXYZ

ABCDEFG
HIJKLM
NOPQRST
UVWXYZ

Here is the same Basic Script Capital alphabet but scaled down to two spaces tall (instead of four):

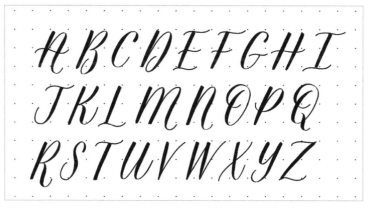

Flowy Script Capitals

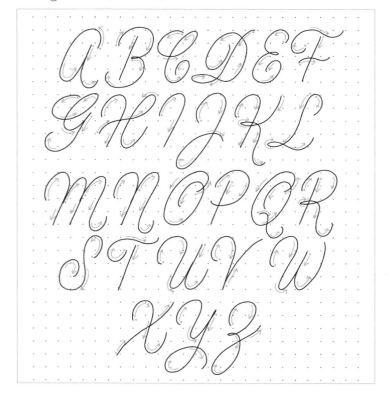

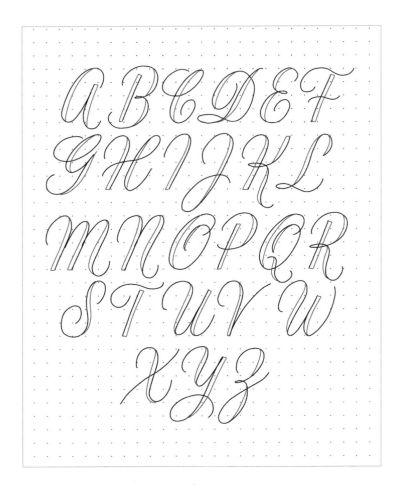

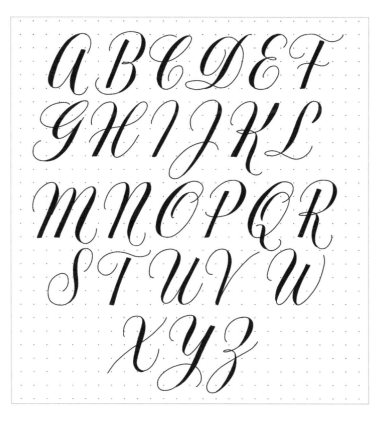

Here is the same Flowy Script Capital alphabet but scaled down to two spaces tall (instead of four):

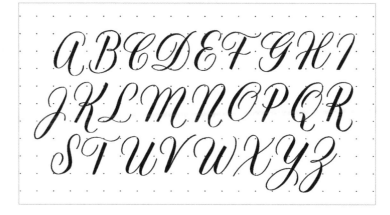

Chapter 10

Incorporating Capitals Into Words

Unlike lowercase letters, script capitals don't need to be connected to the letter that follows.

Capital letters that end higher than the lowercase letters, such as V and W, would be tricky to connect to a lowercase letter because of the height difference. Capitals that end on the left side of the letter, such as S, wouldn't be able to connect easily to the next lowercase letter on its right. In these cases, the connection is eliminated, and the lowercase letter starts separately from the capital.

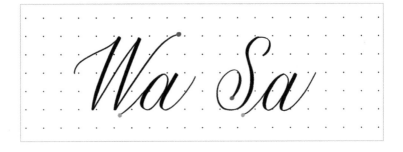

There are some instances where it would make sense to connect a script capital to the next lowercase letter. If the capital letter ends at the bottom right, then the exiting stroke of the capital could become an entrance stroke to a lowercase letter. Some capitals might even have multiple ways of joining to a lowercase letter.

On the next page are a few examples to get you started. The left column shows the letters connected together, and the right column examples are left unconnected:

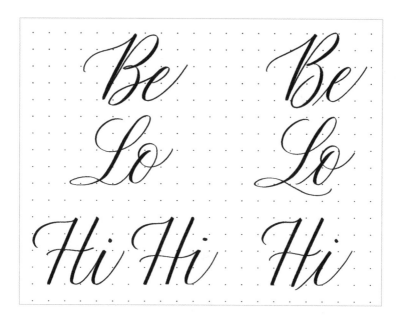

The style of the letter might influence how it connects to the next letter. For example, the Basic Script D could loop through and connect to the lowercase letter, but the Flowy Script D doesn't connect because the exiting stroke is on the top left side of the letter.

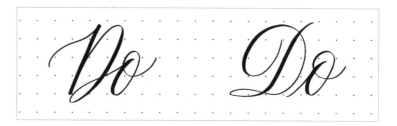

You can get creative with some connections, such as capital T to lowercase h. The crossbar of the T can be combined with, or cross through, the upper loop of the h. The third example shows how to leave them unconnected:

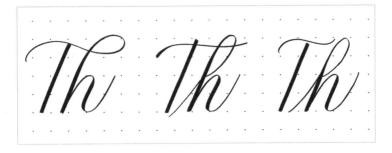

Don't be afraid to try out a few different options for connecting a capital letter to the next one, but you might find it works better if you don't connect them at all.

In addition to legibility, it's important to mind the spacing. The space between a capital letter and a lowercase letter should be the same as the space between lowercase letters. If the spacing is too far apart, the lowercase segment could appear to be a word of its own, but keeping them too close together could interfere with legibility.

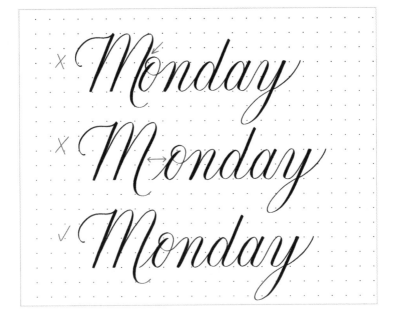

Takeaways

- If you are stringing together capitals, we recommend using block caps instead of script for readability.

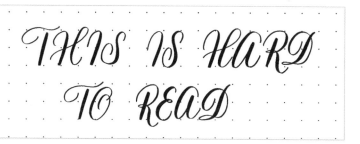

- You can choose whether to connect a capital letter to the following lowercase letter, as long as you maintain proper spacing and legibility.

Chapter 11

Numbers

If you use a planner or journal, chances are that you'll need to write down numbers to keep track of important dates or to log any numerical tracking. For important numbers like these, we recommend you use a clear, basic style:

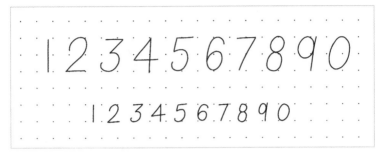

To make your numbers look fancier for special occasions like birthdays, here's another example that would pair well with script lettering:

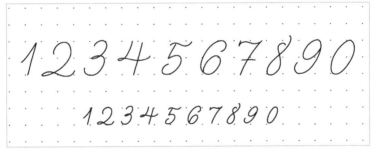

The concepts of shading also apply to numbers:

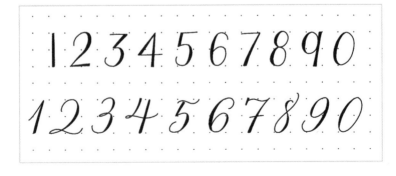

Chapter 12

How to Experiment with Your Style

There are endless ways to write the alphabet. Just think about how many fonts exist! Some general categories of script alphabet styles include: simple, loopy, bouncy, flourished, expanded, narrow, slanted, elegant, chunky... you get the idea.

But it can be tricky to come up with new styles out of thin air. The way we approach letter variation is by starting with the basics and changing a few characteristics at a time.

General Characteristics to Vary

Changing simple characteristics in the individual letters can make a big impact on the overall look of a word. All of these traits listed below apply to the letter as a whole, rather than the letter components, and can be applied to lowercase and capital alphabets.

1. Roundness (round vs. pointy)
2. Slant Angle (slanted vs. upright)
3. Proportions (short/wide vs. tall/narrow)
4. Thickness (light vs. heavy downstrokes)

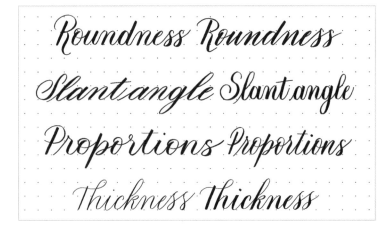

The key is to be consistent. For instance, if you choose to vary the angle of the letters (upright vs. slanted), you will want to make sure that all the letters in the word are changed the same way. If the first half of the word is slanted and the second half is upright, the word will become hard to read and look a little "off."

Lowercase Characteristics to Vary

In addition to changing the letter style as a whole, you can also adjust individual components of the lowercase letters. Some letters share common elements, such as letters with upper loops or lower loops. You can make a change to an individual component across all letters in the word containing that shape.

Here are some characteristics that can be changed, with the word "holiday" as an example on the next page:

1. Normal loop size
2. Short and wide loops
3. Straight line instead of a loop
4. Tall and narrow loops

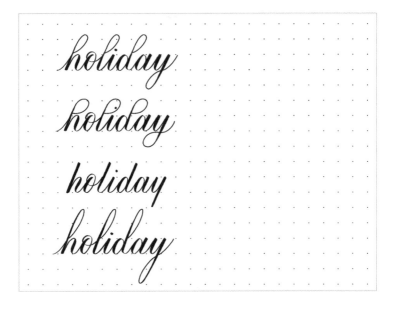

It's pretty amazing that changing just one characteristic can create a totally different style. This same concept can be applied to all of the basic shapes that recur throughout the alphabet, such as the ovals. Get creative with it!

Capital Characteristics to Vary

The simplest way to change up the look of the word by varying the capitals is to adjust the height in relation to the lowercase letters. In the example below, *all the lowercase letters are exactly the same*. We've simply changed the height of the capital letters and the end result is completely different.

Tall Capital Letters

Short Capital Letters

Another characteristic to experiment with when it comes to capitals, especially block caps, is the position of the midline. The two examples below show how moving the midline up or down causes a drastic change in the alphabet style.

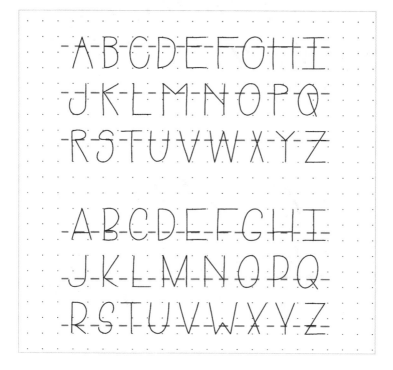

The last characteristic in script capitals is the entry element. Since script capitals typically appear at the beginning of a sentence, there's opportunity to make them stand out. Building off the basic script alphabets, you can add entry elements to create a more embellished style.

Here are two ways to enhance the Basic Script Capital alphabet simply by adding entry elements to some of the letters:

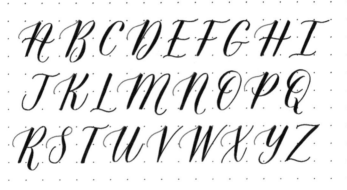

The Flowy Script Capital alphabet can be embellished by extending the loops into spirals:

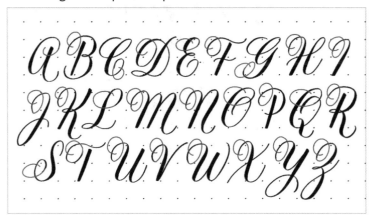

These examples are just starting points. There are so many possibilities to make unique script capitals, and we encourage you to test different ideas until you find your favorite!

Word Characteristics to Vary

So far we've experimented with general characteristics and the components that make up the letters in order to create new styles. Taking a step back, we can also look at the word as a whole and try new things, like varying the letter spacing and the baseline. Spacing can be very tight, very loose, or anywhere in between, and the baseline can be strict or flowy.

tight spacing

loose spacing

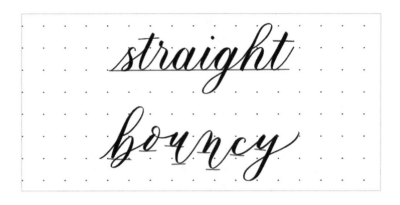

Combining Characteristics

You can change several characteristics at a time when you're writing a word or phrase. For instance, you can adjust the roundness and angle at the same time to make a pointy and slanted style, and you can even add on more variations to fundamentally change the look. The word "Monday" below is written normally in the first instance, then with other variations added on. The third version looks completely different, but we've only changed four characteristics (pointy + slanted + bouncy + narrow).

If you're feeling overwhelmed (totally normal), just pick two or three things to stylize at a time. You can also try working on a new style each month. After a few months, you might start to notice a trend or find your favorite style.

Consistency

If you decide to pick a characteristic to vary, we recommend using that change on other similar letters. For example, if you change the loop of your lowercase "g" to be large and loopy, use the same style of loop on the "j" and "y" rather than making each loop different.

The same is true for spacing and baseline adjustments. This level of consistency will result in a more dramatic overall effect and will make your stylistic choice looks intentional.

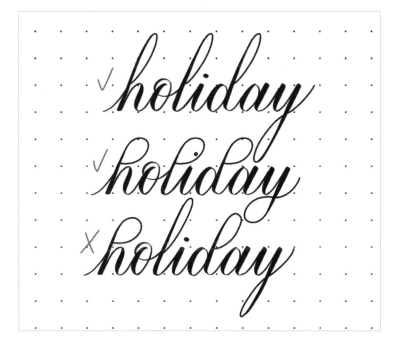

A Note on Using Other Artist's Work for Style Inspiration

It's perfectly fine to use Instagram, Pinterest, or the home décor section at a store as inspiration for lettering and calligraphy. In fact, that may be how you became interested in this craft.

It's also fine to look at other artists' lettering pieces and to try re-creating them as a practice exercise. But make sure that you use these places for inspiration *only*, and always give proper credit to the original artist.

- **Example 1:** If you copy someone else's piece as a way to practice and learn, don't share a picture of your version online because that implies that you were the original artist.

- **Example 2:** If you see another artist's pretty journal page on Instagram and decide to try a similar style to share online, add a sentence in your caption such as, "design inspired by (tag the person)."

Please note that this is not legal advice and that you should always double check relevant laws, marks, and copyright notices. When in doubt, ask the original artist.

Takeaways

- Experiment with different styles by picking a couple of small things to experiment with at once.

- The characteristics you can vary include general letter characteristics (e.g. slant), letter components (e.g. larger loops), proportions and midline of capitals, entry elements, spacing, and baseline.

- Consistency is key for creating an intentional stylistic statement.

Chapter 13

Flourishing

What Is Flourishing?

Flourishing is another word for embellishing. Adding embellishments to the letters can make a word look more fancy, decorative, and noticeable.

The purple lines in the word below are all examples of flourishes that are extensions of the core letter. They fill up the space and add style and interest to the letters but do not take away from legibility.

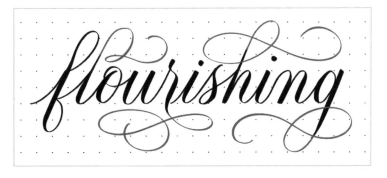

Flourishes can range from simple to complex. Simple flourishes are made of basic curves and loops, while complex flourishes have curves that cross over themselves multiple times and can even have small loops inside larger ones.

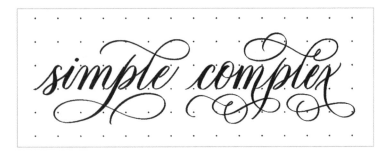

You can flourish a single word or an entire layout to interlock the words together.

While flourishing may seem overwhelming at first, we have just three tips that you should keep in mind:

1. Flourishes are based on oval shapes.
2. Lines should cross at 90 degrees.
3. Do not cross two thick lines.

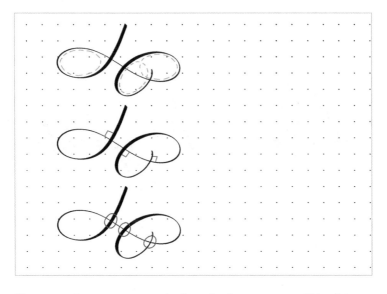

The most important part is that the letters are still legible. The flourishes shouldn't distract from the words but should enhance the lettering.

The Best Places to Add Flourishes

Some areas within a word are better for flourishing than others. Why? Because adding a flourish extends a letter beyond where it normally "lives." While some additions

create beauty and balance, be careful not to interfere with other letters or the overall legibility. We've come up with the five best places to add flourishes, as pointed out below:

1. Upper loops
2. Lower loops
3. T-crossbars
4. End of word
5. Under the word

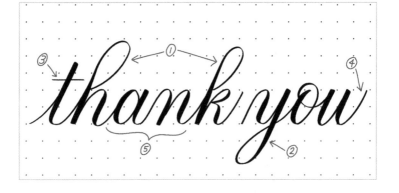

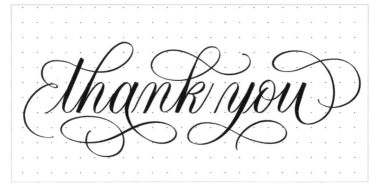

Let's look at some examples of each of these five places to flourish.

Upper Loop Flourish Examples

Letters in this category: b, d, f, h, k, l

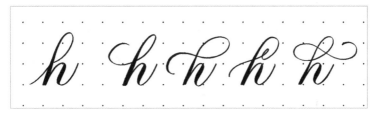

Lower Loop Flourish Examples

Letters in this category: f, g, j, p, q, y, z

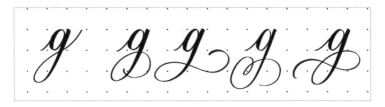

T-Crossbar Flourish Examples

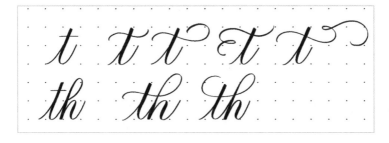

End of Word Flourish Examples

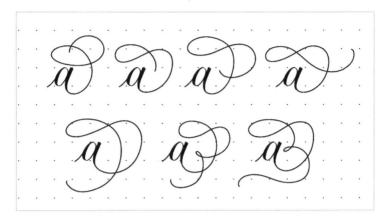

Under the Word Flourish Examples

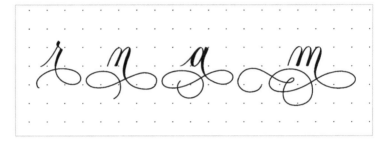

A few more things to keep in mind as you continue to practice flourishing:

- Loops and curves should be smooth, not pointy or choppy.

- The shapes should be large enough that the flourish looks intentional. A tiny loop might look like a mistake or a distraction.

- Maintain overall balance by placing flourishes evenly around the word.

25 Ways to Flourish the Letter Y

There are endless ways to create flourishes by changing up variables such as the loop size and angle, size of the "tail," number of intersections, spirals, and adding inner loops.

Here are twenty-five ways to flourish the letter "y" to use for inspiration. You can apply the same concepts to other letters as well.

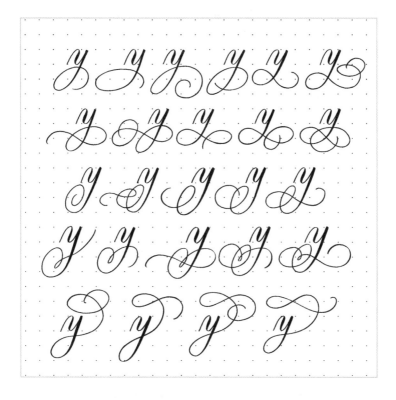

Bonus: Entry and Exit Swash Templates

Another way to add flourishing to your word is by using entry and exit swashes. This works particularly well when you have a single word or short phrase centered on a page with room on either side. You can add these to a plain, non-flourished word to give it some extra embellishment, or add on to a simple flourished phrase.

Here are some examples of our favorite swashes to add at the beginning and end of a line:

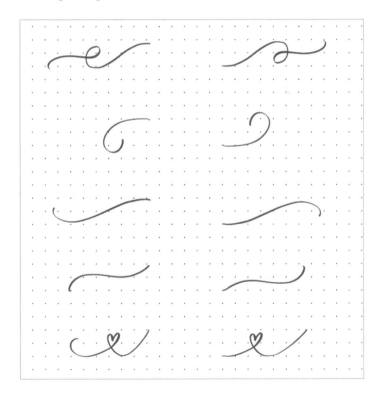

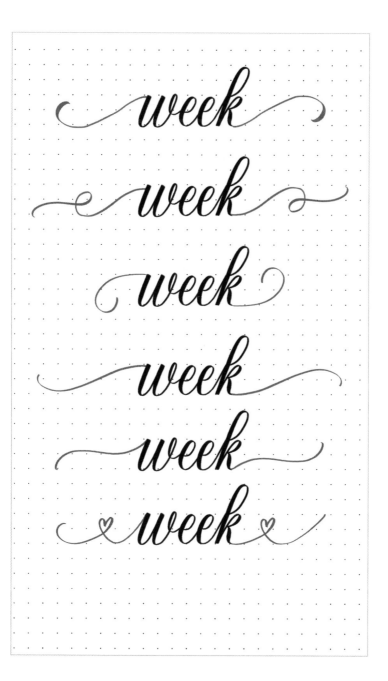

Takeaways

- There are three main rules to remember when flourishing: Flourishes are based on oval shapes, lines should cross at 90 degrees, and two thick lines should never cross.

- Due to the nature of flourishes, there are certain spots that work better than others: upper loops, lower loops, t-crossbars, end of words, and under the word.

- A bonus way to flourish is by creating an entry/exit swash combination to add on to an existing word.

Chapter 14

Decorations and Embellishments

One of our favorite ways to enhance an overall theme is through decorations and embellishments. We've come up with our top five ways to add decorations that pair well with lettering. For each, make sure that they don't detract from the legibility, but rather add to the page as a whole.

Decorate the Space within the Letter Gap

When you create letters in faux calligraphy, a gap is formed between the parallel lines of the downstrokes. Coloring in the gap creates a realistic calligraphy look, but the open space is also an opportunity to add decoration. Using different colors and patterns within the downstrokes creates a whole different look. Here are some pattern ideas to get you started:

- Stripes
- Dots/stippling
- Criss-cross/zig-zag
- Galaxy
- Flowers
- Solid color
- Ombre/blending

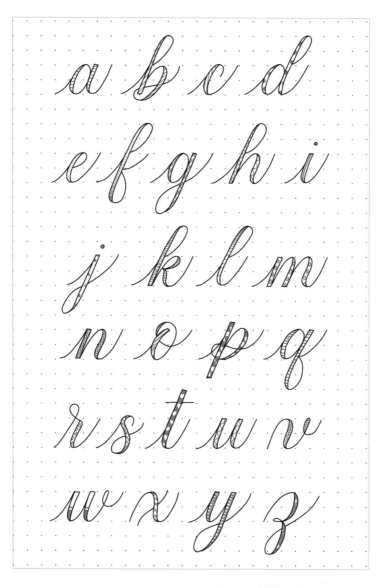

Important note: If you decide to use a pattern within the gap, you'll need to pay close attention to where the letters cross over themselves. You'll want to leave these spaces open. For example, normally for the lowercase "t," the line goes straight through the stem. This line would interfere

with the pattern. To avoid this, lift your pen in the middle of the crossbar when you hit the stem so that the gap stays open and your pattern is uninterrupted. Compound curves (like the last part of the "h") are another area to look at if you normally add shading on either side of the skeleton. Refer back to the downstroke creation section to see alternative ways to create the compound curve.

Below are some examples of letters that cross back through themselves but be on the lookout for other spots to lift your pen. This requires some forward thinking so if you're having trouble, just draw your letters in pencil and ink over the outline.

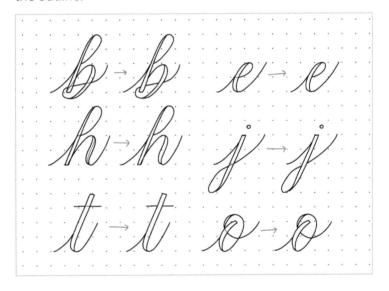

Create Shadows

The easiest way to think about drawing shadows is to trace one side of the letter that you've already created. We find that the right side is more commonly shadowed.

The shadow will also drop below the letter. Stay consistent with which side you're tracing for the best effect, and try to keep the thickness of the shadow consistent. Here are three different styles of shadows and how to create them:

1. Draw a simple line on the right side of the letter, leaving space between the letter and the line.

2. Similar to the first method, but in this style connect the ends of the shadow line to the letter.

3. Fill in the gap between the shadow line and the letter so that the shadow touches the letter.

The picture shows the three shadow methods for the letter "h" and a small box.

Here's the lowercase alphabet with shadows in purple for your reference—try practicing on your own and afterward comparing it to the example to test your skill!

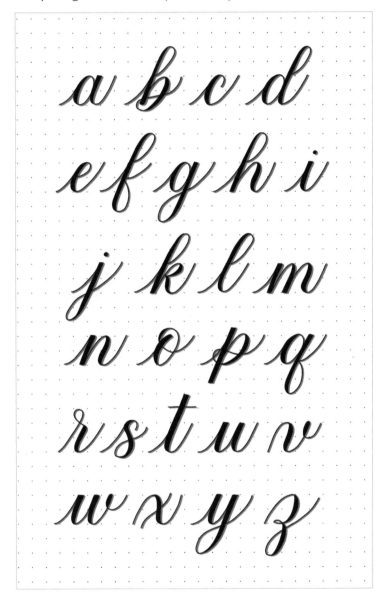

Shadows can also be added to block capitals, and it looks really neat if you add shadows to the outlined capitals.

Add Serifs to Block Caps

Serifs are small embellishments added onto the ends of the capital letters. They can be a simple, straight line, or you can try out different shapes like dots or triangles. On the next page are some examples to get you started.

ABCDEFGHI
JKLMNOPQ
RSTUVWXYZ

ABCDEFGHI
JKLMNOPQ
RSTUVWXYZ

ABCDEFGHI
JKLMNOPQ
RSTUVWXYZ

Create Banners

What's another fun way to make your words stand out?
Banners! They can be as simple as a rectangle with a triangle
cut-out on either side, or as complex as a ribbon that folds
over itself to create depth. Incorporating curved lines is
a little trickier but gives more movement to the piece. To
ensure that your word will fit inside the banner, try writing
your word first in pencil and planning the banner around it.

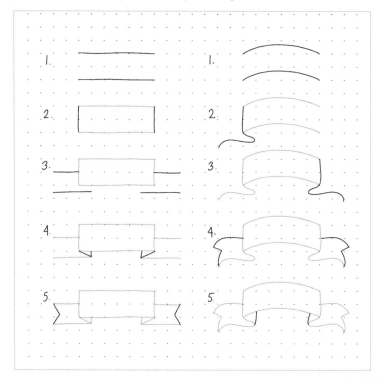

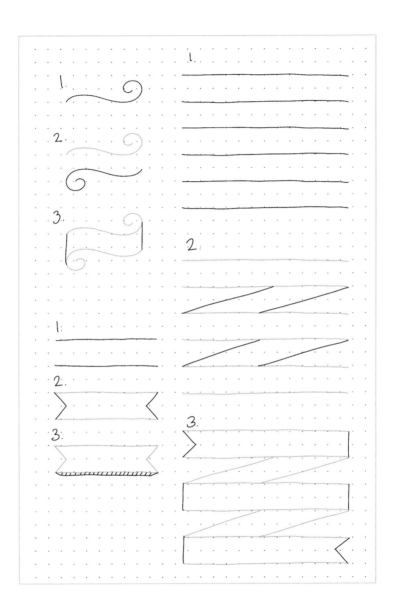

Draw Basic Florals

Doodles and illustrations are an excellent way to decorate and fill up space in your journal, and some of our favorites are leaves and stems. You can add them under and around your words, or incorporate them into the letters themselves.

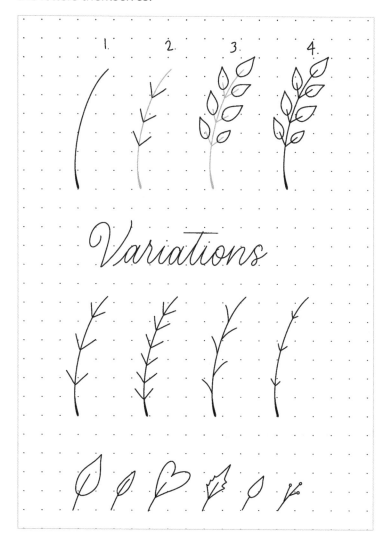

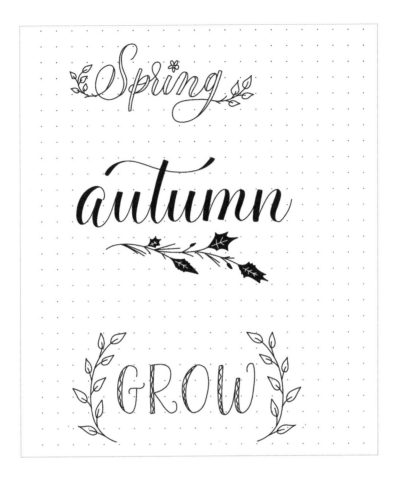

Takeaways

- Our five favorite ways to add embellishments are: filling letter gaps with patterns, creating shadows, adding serifs to block caps, creating banners, and drawing basic florals.

- The decorative elements shouldn't inhibit the legibility of the words, but should enhance the lettering.

Chapter 15

Composition: Putting It All Together

It's time to put together everything you've learned! To us, composition is the process of arranging words into a layout using multiple styles and elements to enhance the overall message. In other words, instead of writing every single word in the same style on a straight line, we're going to add visual interest by purposefully changing the styles and layout.

Letter variations, alphabet styles, embellishments, decorations...you can come up with an infinite number of ways to change it up. Script lettering and block capital letters complement one another, especially for quotes and phrases. Writing select words in calligraphy and the rest in block capitals can help emphasize the most important parts. Pairing two lettering styles also makes the piece more interesting and gives it personality.

Varying the direction of the baseline can add some visual interested to your layout. Create curves, diagonals, or other shapes rather than keeping everything on a straight line. Starting with pencil is very important in this process!

The examples below show variations of mixing and matching elements of lettering to create interesting, unique titles and headers. These examples barely scratch the surface of what's possible.

MIX AND MATCH

Letter Styles

FITNESS
goals

To-do
LIST

GRANDMA'S
Birthday

BOOKS
to read

MOOD
tracker

Grocery
LIST

habit
TRACKER

habit
TRACKER

We know that it can be a little overwhelming to come up with new composition styles for writing a title or quote, so let's start with some basic ways to change up your lettering. You can pair large and small letters to make certain words stand out, you can choose to embellish certain words while

keeping the others plain, or you can change up the shape that your letters follow.

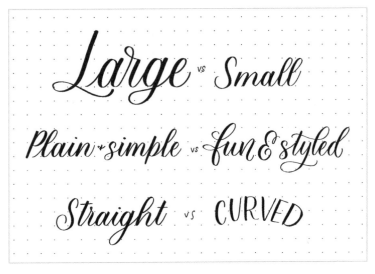

In addition to varying the elements above, you can combine different styles on top of one another, such as using block capitals behind script lettering. Start by outlining the block capitals or writing them with a lighter colored marker, then draw the script lettering on top, adding extra space between the letters.

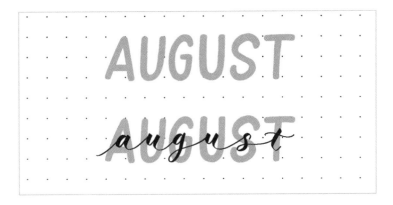

And, of course, you can add any other illustrative embellishments to enhance the look, such as banners, shadows, and patterns.

Let's walk through the process of creating composition using a short quote: "Focus on what matters."

Step 1: Choose Words to Emphasize

The first step is to determine which words are the most important or need to stand out. If everything stands out, nothing will. That's why we pick just a few to emphasize. Some ways to make words stand out are by making them larger, bolder, or otherwise more visible (e.g. with flourishes or within a banner).

We like to start by writing the quote in normal handwriting first. Then we can focus on defining which words we want to stand out, usually with a star or box, leaving the others unmarked. This creates two levels: important words and unimportant words.

For longer quotes, there may be a third hierarchy, e.g. very important words, semi-important words, and unimportant words.

Don't overthink this step; just pick out the words you think should stand out the most.

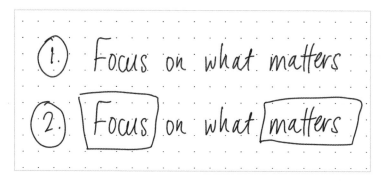

Step 2: Create Rough Sketches

Using this hierarchy, we'll roughly sketch out ideas of how the quote can be laid out in pencil. We created four options to start. The sketches are meant to be rough layouts, not masterpieces, so don't worry about being perfect. You can start to add in some characteristics, such as the curved baseline in example number three and the mixing and matching of script and caps in number four.

Step 3: Refine the Chosen Sketch

Next, pick the sketch that you like the most. We'll pick the third sketch. Using a pencil, refine the sketch with more precise placement and letter forms than in the original brainstorm.

In addition to the curved baselines, we've decided to use shaded capitals for the two most important words, and a smaller sized monoline script for the middle.

Work on it until you're happy with how it looks, then ink over the sketch! Some of the key things to watch out for are spacing, alignment of text, and legibility. You can add little details, such as the two dots and lines we added in our final version below.

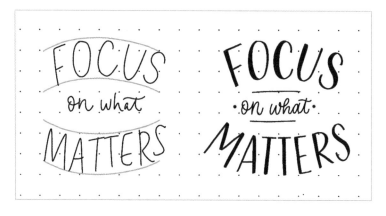

We've taken the same quote and changed other aspects to create three more unique compositions. The first uses faux calligraphy filled with a stippled pattern for the word "focus," paired with simple, small block capital letters. The faux calligraphy includes an entry and exit swash.

The next variation uses flourishing to make an impact. The flourished script is balanced by small block caps with simple serifs.

Lastly, we used a banner to create the overall structure of this piece. The lettering is all the same style, with entry and exit swashes leading into bouncy modern calligraphy, and the words are centered within the banner.

We suggest that you pick two to four characteristics to work on in a single composition at a time, especially if it's only a few words. This could mean picking two different lettering styles (e.g. block caps and bouncy script), then adding on a simple banner, or using one lettering style with various baseline shapes and shadows.

If you're stuck, some pleasing lettering style pairs are:

- ◆ Simple script with shaded block caps
- ◆ Flourished script with serif caps
- ◆ Bouncy script with simple block caps

Again, sketching the design in pencil on a scrap piece of paper can really help with the composition process.

On the next page are some additional ideas to get you started.

TALL+SKINNY

mono script

Script

SHADOW

S.MALL C.A.P.S.

Bold script

FAUX

patterns

CAPS

loose script

Script

C.A.P.S

Curved

BASELINE

Takeaways

- Instead of writing each word the same every time, you can use different compositional elements to make your lettering more exciting and to emphasize the important words.

- Pick several elements to combine into new looks.

- Whatever you choose, keep an eye on the overall spacing and legibility.

Chapter 16

Alphabet Examples

Lowercase Alphabets

a b c d

e f g h i

j k l m

n o p q

r s t u v

w x y z

a b c d
e f g h i
j k l m
n o p q
r s t u v
w x y z

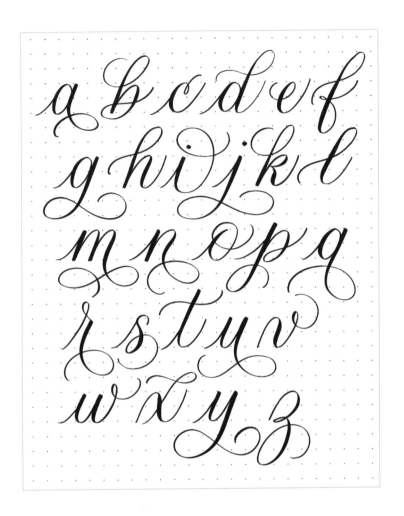

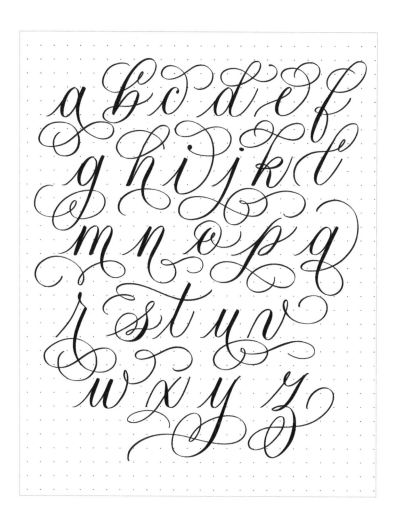

a b c d e f

g h i j k l

m n o p q

r s t u v

w x y z

a b c d
e f g h i
j k l m
n o p q
r s t u v
w x y z

Capital Alphabets

ABCDEFGHI
JKLMNOPQ
RSTUVWXYZ

ABCDEFGHI
JKLMNOPQ
RSTUVWXYZ

ABCDEFGHI
JKLMNOPQ
RSTUVWXYZ

ABCDEFGHI
JKLMNOPQ
RSTUVWXYZ

ABCDEFGHI
JKLMNOPQ
RSTUVWXYZ

ABCDEFGHI
JKLMNOPQ
RSTUVWXYZ

ABCDEFGHI
JKLMNOPQ
RSTUVWXYZ

ABCDEFGHI
JKLMNOPQ
RSTUVWXYZ

ABCDEFGHI
JKLMNOPQ
RSTUVWXYZ

ABCDEFGHI
JKLMNOPQ
RSTUVWXYZ

ABCDEFGHI
JKLMNOPQR
STUVWXYZ

ABCDEFGHI
JKLMNOPQR
STUVWXYZ

Chapter 17

Word Examples

In this final chapter you'll find several lettering variations of words that you will likely need for your planner or bullet journal.

The words are divided into these categories:

◊ Days and Months

◊ Food and Habits

◊ Organizing and Finances

◊ Chores and Celebrations

◊ Just for Fun

All the example words are shown in these 5 styles:

◊ Basic

◊ Modern/bouncy

◊ Simple flourish

◊ Complex flourish

◊ Edgy

As always, feel free to be creative and add your own style. Go back to sections you enjoyed in this book and use all of the tools you've learned to letter your own unique way!

Days	Months
Sunday	January
Monday	February
Tuesday	March
Wednesday	April
Thursday	May
Friday	June
Saturday	July
	August
	September
	October
	November
	December

Food Habits

groceries trackers

meals exercise

snacks steps

diet water

nutrition health

 gratitude

 mood

 sleep

Organize Finances
notes bills
future log money
goals expenses
checklist budget
dreams accounts
monthly
weekly
yearly
to do
appointment

Chores Celebrate
laundry holiday
shopping birthday
maintenance anniversary
clean house gifts
mow lawn
garden

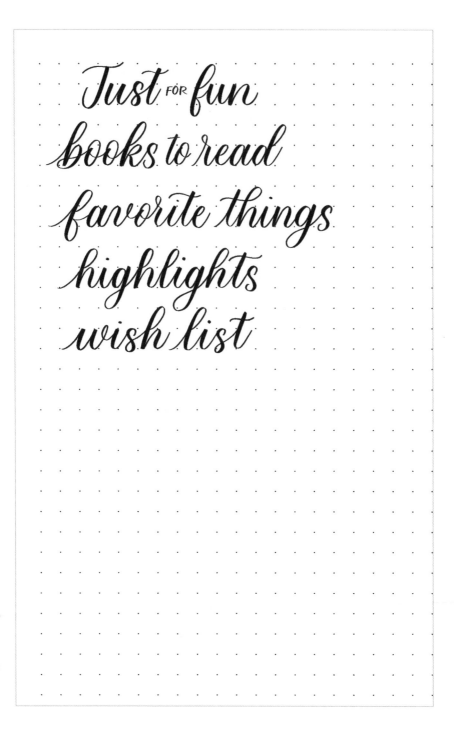

Just for fun
books to read
favorite things
highlights
wish list

Days

Sunday
Monday
Tuesday
Wednesday
Thursday
Friday
Saturday

Months

January
February
March
April
May
June
July
August
September
October
November
December

Food Habits
groceries trackers
meals exercise
snacks steps
diet water
nutrition health
 gratitude
 mood
 sleep

Organize
notes
future log
goals
checklist
dreams
monthly
weekly
yearly
to do
appointment

Finances
bills
money
expenses
budget
accounts

Chores Celebrate
laundry holiday
shopping birthday
maintenance anniversary
clean house gifts
mow lawn
garden

Just FOR fun

books to read

favorite things

highlights

wish list

Days

Sunday

Monday

Tuesday

Wednesday

Thursday

Friday

Saturday

Months

January

February

March April

May June

July August

September

October

November

December

Food
Groceries
Meals
Snacks
Diet
Nutrition

Habits
Trackers
Exercise
Steps
Water
Health
Gratitude
Mood
Sleep

Organize

Notes

Future Log

Goals

Checklist

Dreams

Monthly

Weekly

Yearly

To-Do List

Appointments

Finances

Bills

Money

Expenses

Budget

Accounts

Chores

Laundry

Shopping

Maintenance

Clean House

Mow Lawn

Garden

Celebrate

Holiday

Birthday

Anniversary

Gifts

Just for fun

Books to Read

Favorite things

Highlights

Wish list

Days

Sunday

Monday

Tuesday

Wednesday

Thursday

Friday

Saturday

Months

January

February

March *April*

May *June*

July *August*

September

October

November

December

Food

Groceries

Meals

Snacks

Diet

Nutrition

Habits

Trackers

Exercise

Steps

Water

Health

Gratitude

Mood

Sleep

Organize

Notes

Future Log

Goals

Checklist

Dreams

Monthly

Weekly

Yearly

To-Do List

Appointments

Finances

Bills

Money

Expenses

Budget

Accounts

Chores Celebrate

Laundry Holiday

Shopping Birthday

Maintenance Anniversary

Clean House Gifts

Mow Lawn

Garden

Just for fun

Books to Read

Favorite things

Highlights

Wish list

Days	Months
Sunday	January
Monday	February
Tuesday	March
Wednesday	April
Thursday	May
Friday	June
Saturday	July
	August
	September
	October
	November
	December

Food

groceries

meals

snacks

diet

nutrition

Habits

trackers

exercise

steps

water

health

gratitude

mood

sleep

Organize

notes

future log

goals

checklist

dreams

monthly

weekly

yearly

to do

appointment

Finances

bills

money

expenses

budget

accounts

Chores Celebrate
laundry holiday
shopping birthday
maintenance anniversary
clean house gifts
mow lawn
garden

Just for fun

books to read

favorite things

highlights

wish list

Conclusion

Congratulations on working your way through this book! We hope that our step-by-step guide has given you the skills you need to add lettering to your everyday life.

We encourage you to refer back to this book throughout your journey as your lettering develops. You'll pick up something new each time, and even the smallest tips can make a difference in how you think about lettering.

If there's a particular section of the book that you feel drawn to, we invite you to focus on that style to start. Remember, you don't have to use every single technique you learned if it doesn't fit with your vision. In fact, even we (Jillian and Jordan) don't use all the same styles as each other, and we're twins! And that's the best part— once you figure out what you like, your lettering will be uniquely yours.

It takes time and practice to feel confident in your lettering, but the most important part is to enjoy the process. We believe in you, and we're honored to be part of your journey.

Happy lettering!

For more resources and freebies related to lettering, visit loveleighloops.com/lettering-for-planners

Acknowledgments

We are so grateful to the people in our lives who have supported us in our business and in writing this book.

To the team at Mango Publishing who helped us tremendously throughout the process, we're grateful to have worked with you on our first book. Special thanks to Hugo for working with us from start to finish and Elina for putting together the beautiful design. Thank you for making this book a reality.

A huge thank you to the creative community on Instagram and Facebook. Since the beginning, we have felt so fortunate to be part of a group of people who support and inspire one another. You have become our "calligrafamily" along the way, and we are grateful for each of you. Thank you for your continued positivity!

And to our fellow calligraphy enthusiasts and teachers who are on a mission to spread the joys of lettering—don't ever stop. You are so talented, and the lettering world is incredibly lucky to have you. You're the reason why the online calligraphy community is the best place on the internet.

To our dear students, we appreciate your constant support and enthusiasm. You keep us going every day. You're the reason we do what we do, and we love watching you grow. And we're always impressed by how you can tell us apart in our videos! Throughout the book, could you tell whose "voice" was used in each section? ;)

To all the teachers we've had in our lives: you've inspired us to share our knowledge and become educators ourselves. Especially to our fifth grade teachers Mrs. DeLuca and Mrs. Lindgren (who had the best handwriting in the world!), for encouraging us to work hard and explore our creativity.

An enormous thank you to our amazing family. To Mom, for being our biggest fan from the start, for keeping us sane on our weekly phone calls, and for giving us advice when we need it. Your lifelong example of empathy and compassion has influenced the way we run our business. To Dad, for believing in us, encouraging us to invest in our business, and teaching us the wise words: "don't do a ho-hum job." Remember when you said we should invent a font when we were twelve? Did you ever expect that our own font would be used in our first published book?

To our brothers, Collin and Austin, for staying out of the craft room when we were kids, continuing to support our art through adulthood, and mostly for providing endless jokes and comic relief in all scenarios, got eem. To our fellow boss-lady and sister-in-law, Megan, who understands the joys and struggles of entrepreneurship and has inspired us in more ways than she knows.

A very special thanks to our husbands for supporting our dreams. Jake, thank you for believing in the potential of our business from the very beginning. Your unwavering support has made all the hard decisions easier. Oh, and thanks for letting me and Jordan put sticky notes all over the walls of our new house when we were planning the book outline! Nick, thank you for encouraging me to pursue my passions especially when I doubted myself. For being patient when Jillian and I spend the whole day (and night) together working on projects like this book. Jake and Nick: We love you more than calligraphy!

About the Authors

Jordan (left) and Jillian (right)

Jillian Reece is an analyst-turned-entrepreneur and the co-founder of Loveleigh Loops, an online educational resource for aspiring letterers. She rediscovered her love of calligraphy in 2015 while building a greeting card business on Etsy and planning her wedding. She gravitates towards a modern brush calligraphy style and loves figuring out step-by-step ways to teach. Her love of art and lettering has turned into a full-time passion and there's nothing she enjoys more than helping her students achieve their goals.

Jordan Truster is an engineer-turned-creative business owner. As a co-founder of Loveleigh Loops, she teaches calligraphy through online courses and specializes in pointed pen, the Copperplate style, and flourishing.

Her engineering background influences her approach to teaching calligraphy as both an art and a science. She loves to break down complicated concepts into logical steps, show students how to analyze their work, and use technology to open a world of possibilities in online education.

Jillian and Jordan are twin sisters who grew up near Cleveland, Ohio and now live a few houses apart in Dayton, Ohio. They've created a highly engaged and supportive online community, and have built a global following of over 75,000 across their online channels.